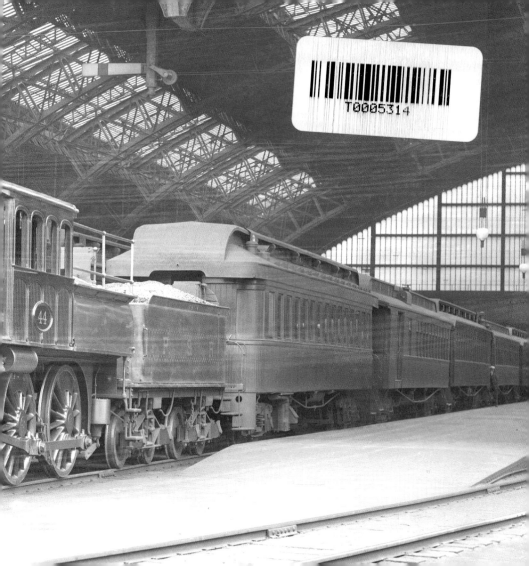

THE
RAILROAD MUSEUM
OF PENNSYLVANIA
IN PICTURES

FRIENDS OF THE RAILROAD MUSEUM
OF PENNSYLVANIA

SCHIFFER
PUBLISHING

4880 Lower Valley Road • Atglen, PA 19310

Introduction

Rising from the rolling hills and lush farmland of Lancaster County is a sprawling complex of exhibit buildings, train tracks, and historic railroad equipment. Together, they tell the story of how railroads changed the lives of people for more than two centuries. For a half a century, the state-owned Railroad Museum of Pennsylvania has preserved and interpreted the commonwealth's rich railroad history. And it has engaged audiences by exploring the role railroads have played, past and present, in building our nation and shaping our daily lives.

Opened on April 22, 1975, the Railroad Museum of Pennsylvania is best known for its world-class collection of approximately one hundred locomotives and railroad cars spanning the mid-nineteenth through the late-twentieth centuries. At the core of this collection are the nearly two dozen historic locomotives and railroad cars preserved by the Pennsylvania Railroad for World's Fairs and other major public exhibitions.

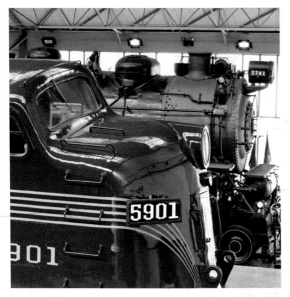

To this core, the Museum has added locomotives and railroad cars representing other railroads and manufacturers over the years. Rounding out the collection are the tens of thousands of smaller artifacts, such as uniforms, tools, lanterns, dining-car china and silver, and archival materials, including countless photographs, negatives, slides, drawings, books, serials, and company records. This renowned collection of railroading artifacts works in concert with the Museum's dynamic exhibits, education programs, and special events to illustrate the countless ways in which railroads have changed people's lives in subtle yet profound ways.

Since 1975, the Railroad Museum of Pennsylvania has grown in size and scope to better tell this story. In 1983, the Friends of the Railroad Museum of Pennsylvania (FRM) was formed to provide preservation, programmatic, and fundraising support. In 1995, the Museum doubled its interior display space with the completion of a 45,000-square-foot addition to Rolling Stock Hall, resembling a grand urban train shed of the late-nineteenth and early-twentieth centuries. Other additions have included a modern restoration shop in 1998, the Stewart Junction railway education center in 1999, the 1915 Golden Age of Railroading Street Scene in 2005, and a new front entrance and atrium in 2007. New exhibits were installed in 2021, with the construction of a new roundhouse exhibit building set to follow. All these expansions have enhanced the Museum's ability to adequately preserve and display its impressive collection of locomotives and railroad cars—many of which are depicted in this photo book. It is my hope that the images contained here bring back great memories of a trip by train, a friend or loved one who worked for a railroad, or a visit with us here at the Railroad Museum of Pennsylvania. Please enjoy!

Patrick C. Morrison
Museum Director

☆ National Register of Historic Places

◢ Pennsylvania Railroad Historical
Collection

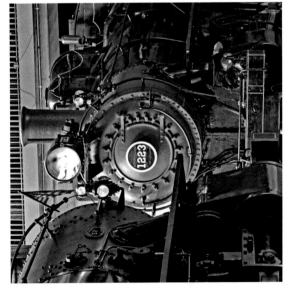

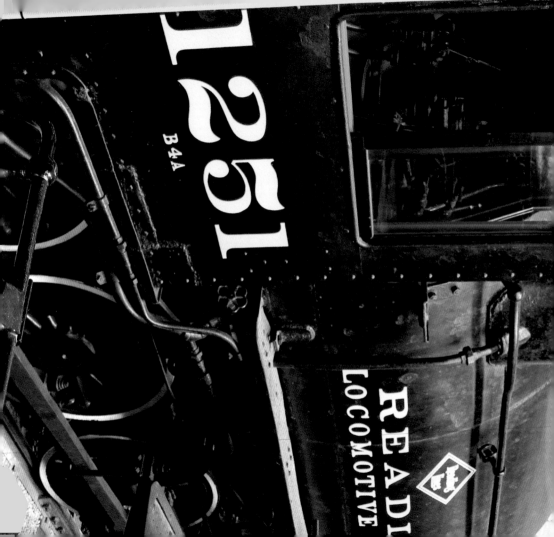

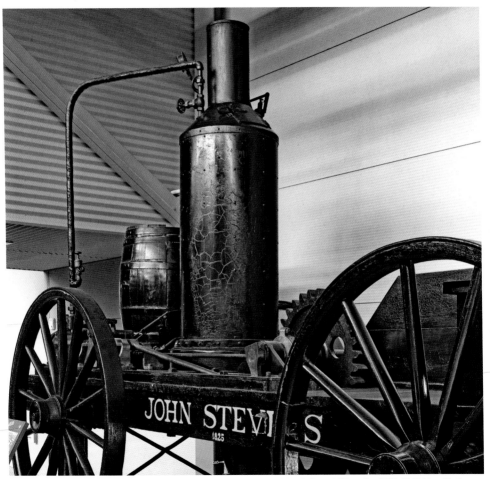

Pennsylvania Railroad replica "John Stevens" locomotive, unnumbered. Built for exhibit at the 1939–1940 New York World's Fair. Replica of an 1825 experimental locomotive by entrepreneur and railroad advocate John Stevens, whose original locomotive was built to demonstrate the potential for using steam power for transportation.

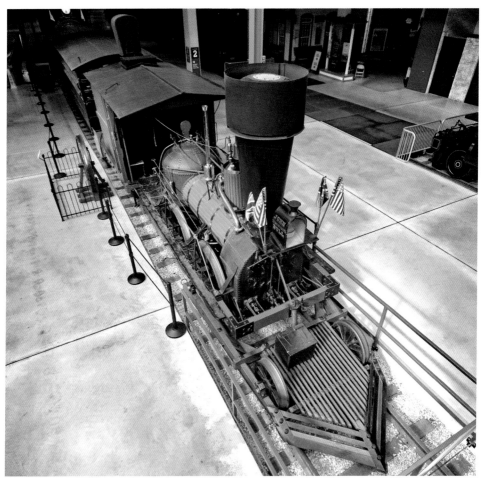

Pennsylvania Railroad "John Bull" replica steam locomotive No. 1. Built in the Altoona Shops as an operable replica for the "Railroads on Parade" pageant at the 1940 season of the New York World's Fair. Used for various promotional films and exhibitions, the John Bull was later restored by the Railroad Museum of Pennsylvania and operated under its own steam until 1999.

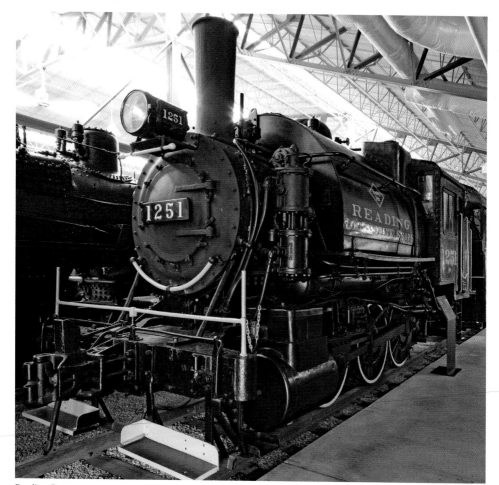

Reading Company steam switching locomotive No. 1251. Built in the Reading Shops in 1918 and retired in 1963. A tank engine, No. 1251, also known as a roundhouse "goat," was the last standard-gauge steam locomotive in the nation to be retired from daily service on a Class 1 railroad.

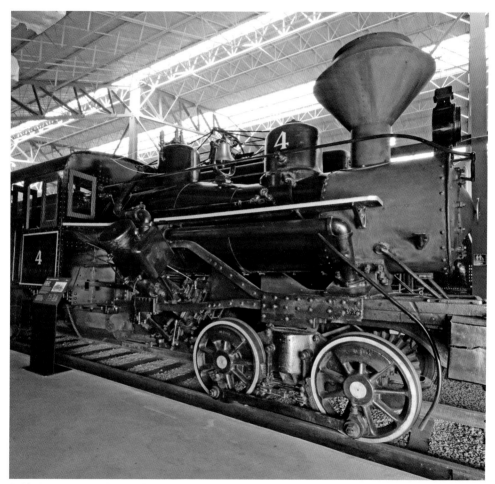

Heisler Locomotive Works geared steam locomotive No. 4. Built by Heisler in 1918 and retired in 1965. No. 4 features a "V" type engine similar in concept to the engine of an automobile. Having spent its career in mining and quarry operations, No. 4 survives to this day as one of fewer than three dozen remaining Heisler products known to exist.

Moore, Keppel & Company Climax No. 4 geared logging locomotive. A 40-ton "Class B" model, No. 4 was built by the Climax Manufacturing Company in 1913 and retired in 1956. The Climax was designed as the ultimate "poor man's" locomotive: powerful and agile, yet cheap and even disposable.

Leetonia Railway Shay geared logging steam locomotive No. 1. Built by the Lima Locomotive Works in 1906 and retired in 1964. Based on a design by lumberman Ephraim Shay, No. 1 operated heavy timber trains over light rails, steep grades, and sharp curves.

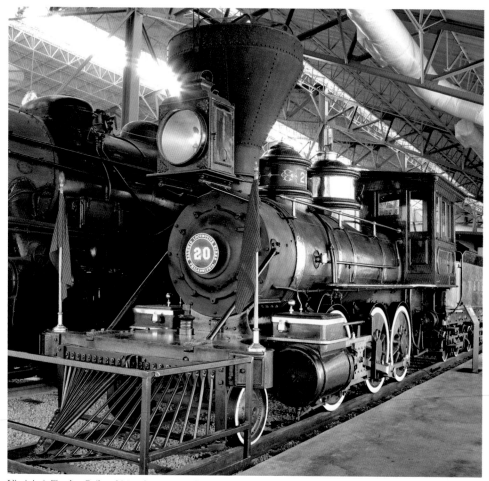

Virginia & Truckee Railroad Mogul-type steam locomotive No. 20, or "Tahoe." Built by the Baldwin Locomotive Works in 1875 and last operated in 1948. Tahoe hauled silver ore and bullion from Nevada's Comstock Lode and also pulled passenger trains. It features a bonnet-style smokestack and ornate brass trim, finished woodwork, and gold leaf.

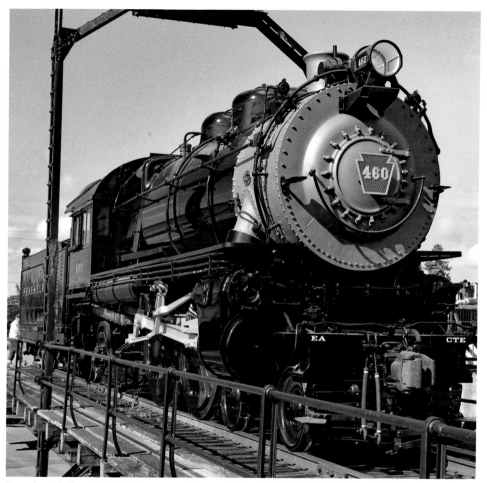

Pennsylvania Railroad E6s Atlantic-type steam locomotive No. 460. Built in the Juniata Shops in 1914 and retired in 1955. Known as the "Lindbergh Engine," the locomotive took on competitors who chartered airplanes in a famous race to deliver to New York City theaters the newsreel footage of aviator Charles Lindbergh receiving the Distinguished Flying Cross from President Calvin Coolidge in Washington, DC. ☆ ⚓

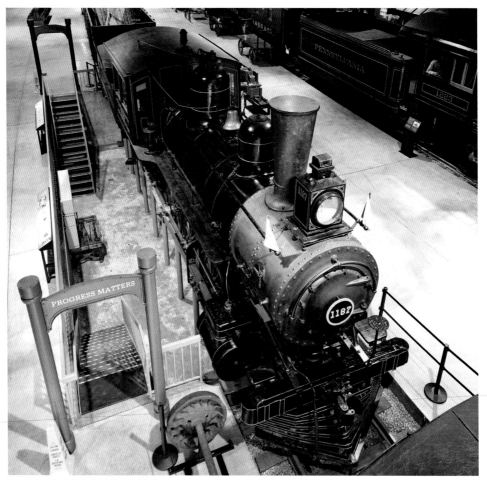

Pennsylvania Railroad H3 Consolidation-type steam locomotive No. 1187. Built in 1888 and retired in 1939. Oldest surviving locomotive built by the railroad's Altoona Shops. Restored by the Pennsylvania Railroad for exhibit at the 1940 season of the New York World's Fair. ☆ ⋏

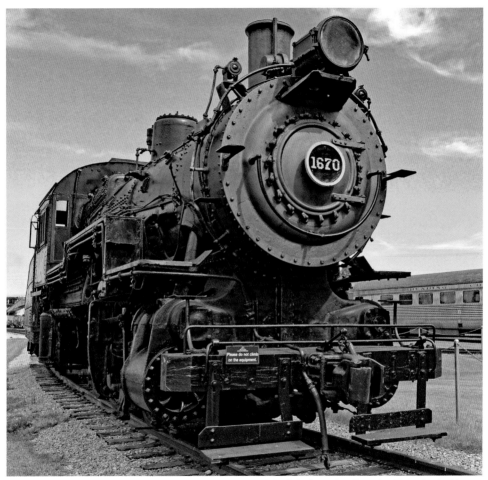

Pennsylvania Railroad B6sb steam switching locomotive No. 1670. Built in the Juniata Shops in 1916 and retired in 1957. Dubbed "yard goats" by train crews, these little locomotives were used mainly in switching yards and terminals, making up freight and passenger trains, and occasionally shuttling goods over short lines and branches. No. 1670 is the sole survivor of its class. ☆ ⋏

Pennsylvania Railroad D16sb American-type steam locomotive No. 1223. Built in the Juniata Shops in 1905 and retired in 1950. Later used on tourist trains, on special excursions, and in the 1969 movie version of the musical *Hello, Dolly!* ☆ ⋏

Pennsylvania Railroad E7s Atlantic-type steam passenger locomotive No. 7002. Originally built in the Altoona Shops as class E2a No. 8063 in 1902, the locomotive was retired from revenue service in 1939 but saw new life as a restored stand-in for "the World's Fastest Locomotive" at the 1949 Chicago Railroad Fair. The original No. 7002 gained fame for setting a ground speed record of 127.1 miles per hour in 1905 but was scrapped in 1934. ✰ ⚲

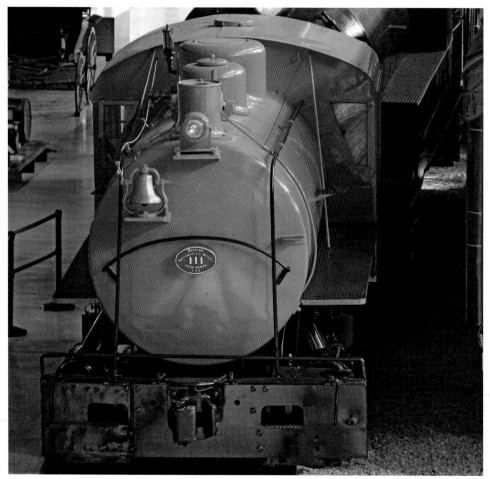

Bethlehem Steel fireless locomotive No. 111. Built by the Erie City Iron Works in 1941 and retired in 1972. No. 111 does not use a fire to make steam and does not produce smoke or sparks. This feature was advantageous when operating in industries where stray sparks could cause fires and where an engine such as this could take advantage of steam being supplied from an on-site boiler house or an outside stationary steam boiler.

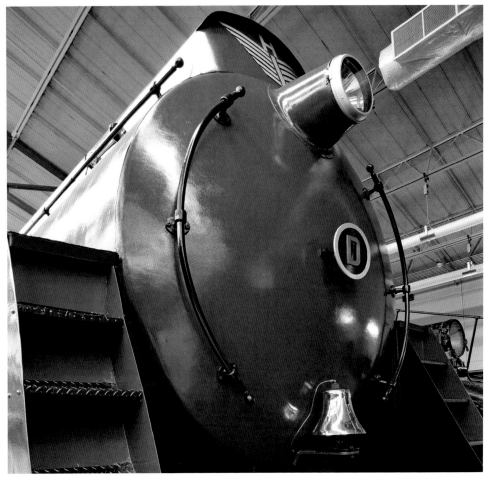

Pennsylvania Power & Light Company fireless steam locomotive "D" No. 4094. Built by the Heisler Locomotive Works in 1939 and retired in 1969. This engine was built and streamlined for its appearance at the 1940 season of the New York World's Fair to show off Heisler's manufacturing capabilities. Engine "D" initially transported wood for a paper company and later coal for a power plant, outliving numerous other steam locomotives.

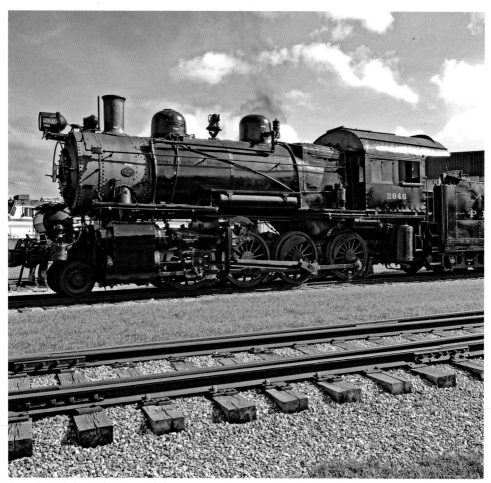

Pennsylvania Railroad H6sb Consolidation-type steam locomotive No. 2846. Built by the Baldwin Locomotive Works in 1905 and retired in 1956. Once one of the railroad's largest and most powerful freight locomotives. ✯ ⋀

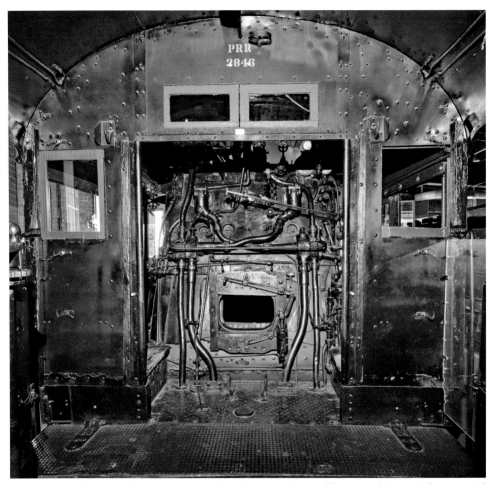

An interior view of the cab of Pennsylvania Railroad H6sb No. 2846. Over its lifetime, No. 2846 received some special equipment upgrades, including a superheater and a power reverse lever, making its daily operation more efficient.

Pennsylvania Railroad GG1 electric locomotive No. 4800. Built in 1934 by the Baldwin Locomotive Works and General Electric and retired in 1979. First locomotive of its class and designated a National Historic Mechanical Engineering Landmark. Nicknamed "Old Rivets" due to the protruding rivet all over the engine's body.

ELECTRIC

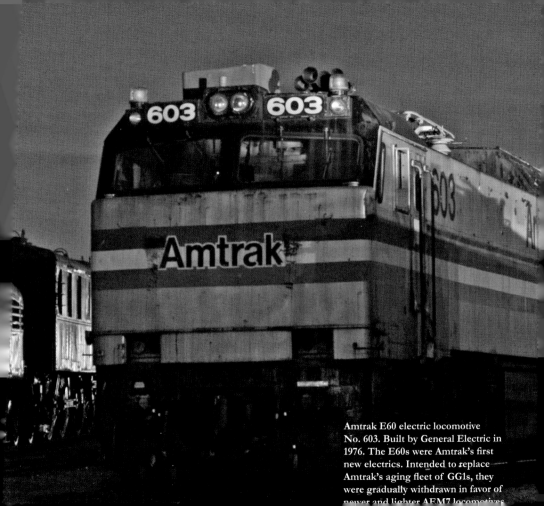

Amtrak E60 electric locomotive No. 603. Built by General Electric in 1976. The E60s were Amtrak's first new electrics. Intended to replace Amtrak's aging fleet of GG1s, they were gradually withdrawn in favor of newer and lighter AEM7 locomotives.

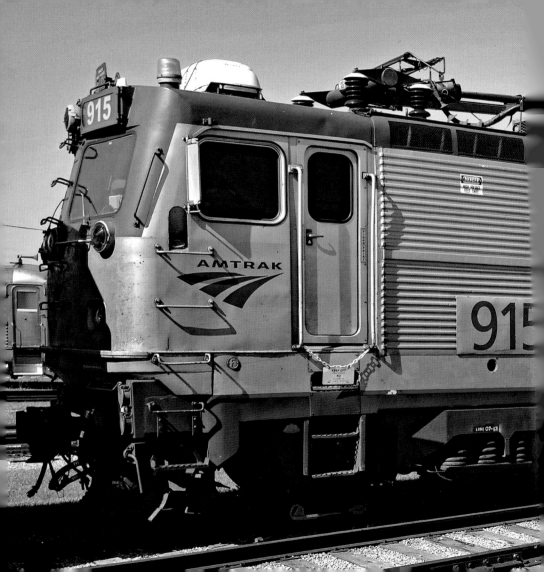

Amtrak AEM7 electric locomotive No. 915. Built by the Electro-Motive Division of General Motors in 1981 and retired in 2015. The lightweight, dual-cab locomotive was built to pull passenger trains at top speeds of more than 100 miles per hour on the electrified corridors of Amtrak's Northeast region.

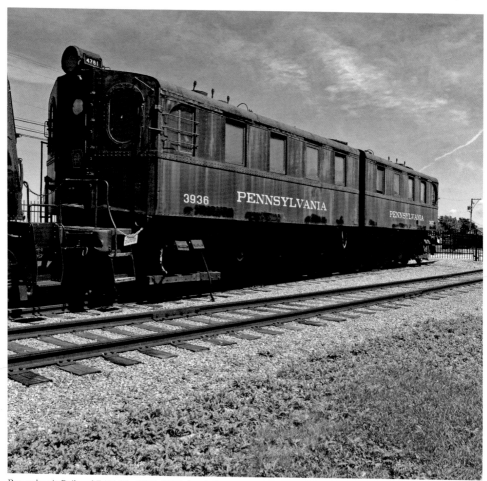

Pennsylvania Railroad DD1 No. 3936–3937 electric locomotive. Built by the Juniata Shops and by Westinghouse Electric in 1911 and retired in 1968. Operated in tunnels under the Hudson and East Rivers to New York's Pennsylvania Station. DD1 locomotives ran as semipermanently coupled pairs, and No. 3936–3937 is the sole survivor of its class. ☆ ⚲

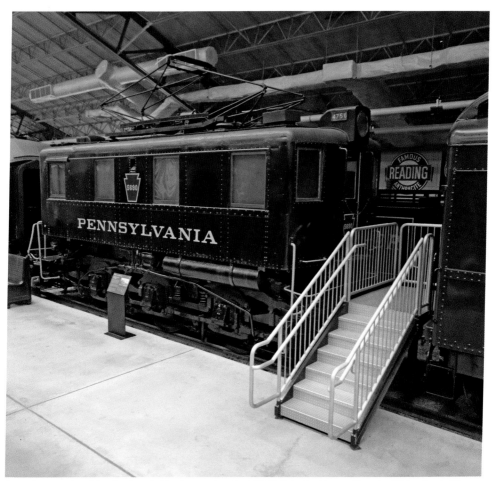

Pennsylvania Railroad B1 electric switching locomotive No. 5690. Built in the Altoona Shops in 1934 and retired in 1971. No. 5690 is the sole survivor of its class, which were dubbed "rats" by train crews for their appearance, small size, and the way they scurried around railroad yards switching train cars.

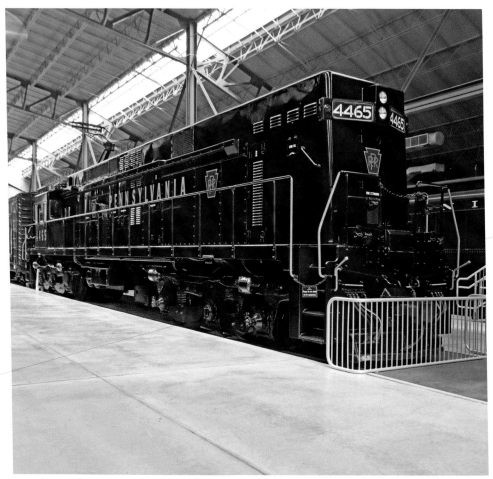

Pennsylvania Railroad E44 electric freight locomotive No. 4465. Built by General Electric in 1963 and retired in 1991. E44s were dubbed "bricks" by train crews, mainly for their boxy appearance. No. 4465 was the last electric locomotive built for the Pennsylvania Railroad.

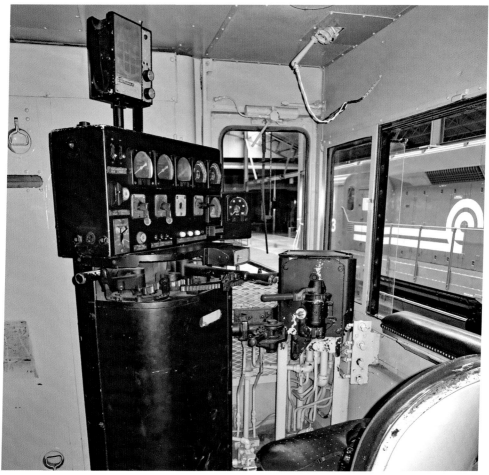

A view of the cab of Pennsylvania Railroad No. 4465 looking outward in the direction of the long hood of the locomotive.

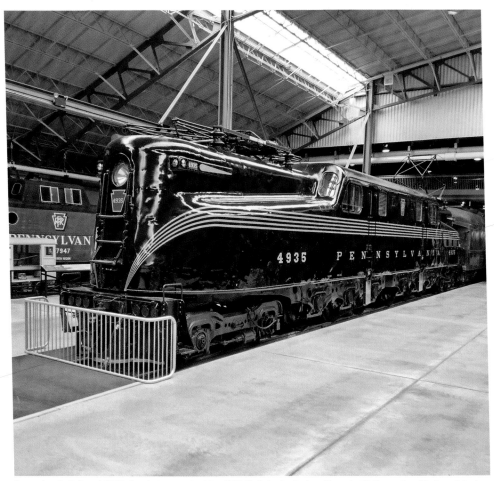

Pennsylvania Railroad GG1 electric locomotive No. 4935. Built in the Juniata Shops in 1943, repainted in its original PRR color scheme in 1977, and retired in 1980.

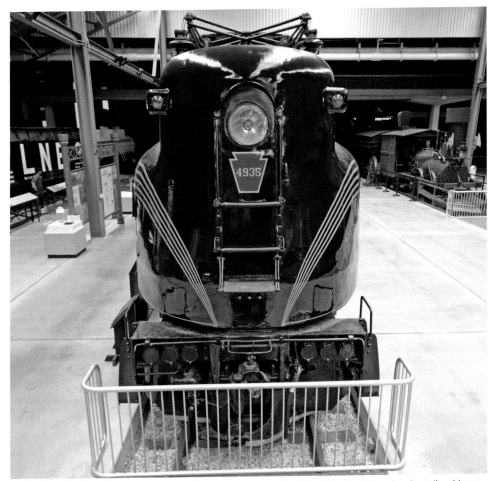

Refinements to the GG1's streamlined design from the prototype (No. 4800, "Old Rivets") are largely attributable to famed industrial designer Raymond Loewy. No. 4935 was nicknamed "Blackjack" by train crews, since the sum of its road numbers equals 21.

DIESEL

Pennsylvania Railroad E7 diesel passenger locomotive
No. 5901. Built by the General Motors Electro-Motive
Division in 1945 and retired in 1973. No. 5901 and sister
engine No. 5900 were the first diesel-electric passenger
locomotives ordered by the Pennsylvania Railroad in 1945.
Today, No. 5901 is the sole survivor of its class.

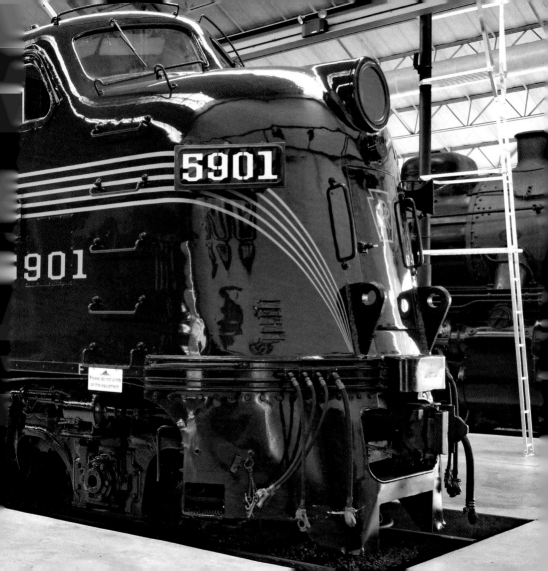

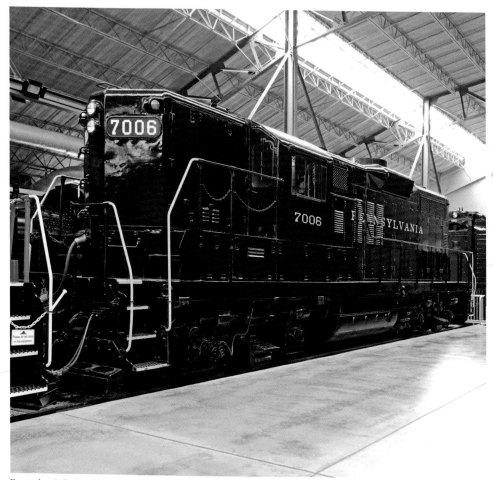

Pennsylvania Railroad GP9 diesel-electric locomotive No. 7006. Built by the General Motors Electro-Motive Division in 1955 and retired in 1985.

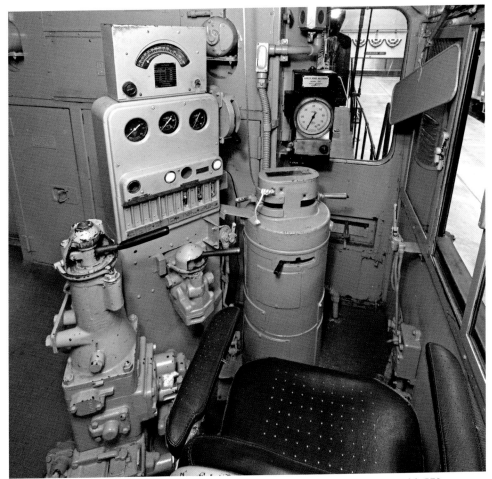

A view from the engineer's seat of Pennsylvania Railroad GP9 No. 7006. A "General Purpose" model, GP9 No. 7006 was at home switching freight cars in a yard, pulling coal trains, or handling a passenger train.

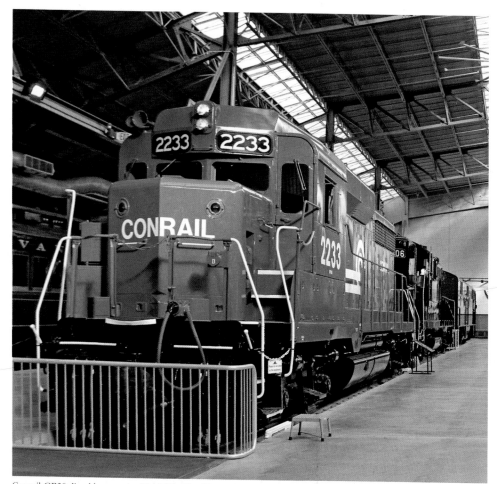

Conrail GP30 diesel locomotive No. 2233. The "General Purpose" GP30s, such as No. 2233, with their distinctive rooflines, were built to meet a demand for greater pulling power and versatility over older "first-generation" diesels.

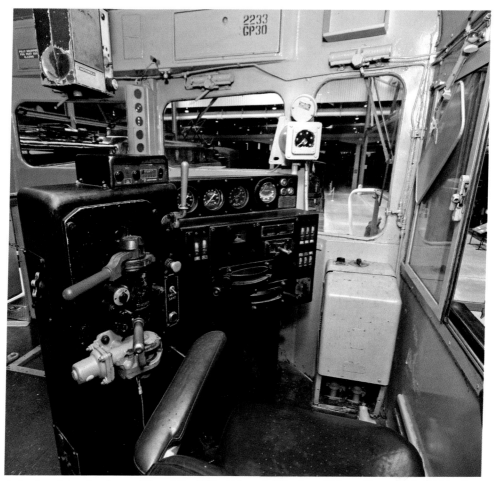

A view from the engineer's seat of Conrail No. 2233, which was built by General Motors Electro-Motive Division for the Pennsylvania Railroad in 1963 and retired in 1984.

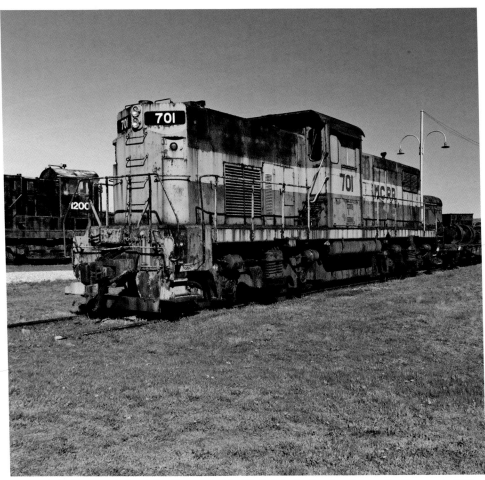

Monongahela Connecting Railroad diesel locomotive No. 701. Built by the American Locomotive Company in 1968. Designed for use in steel mills to move coal, limestone, and molten iron, No. 701's low profile helped it negotiate tight clearances, both inside and between two steel plant complexes.

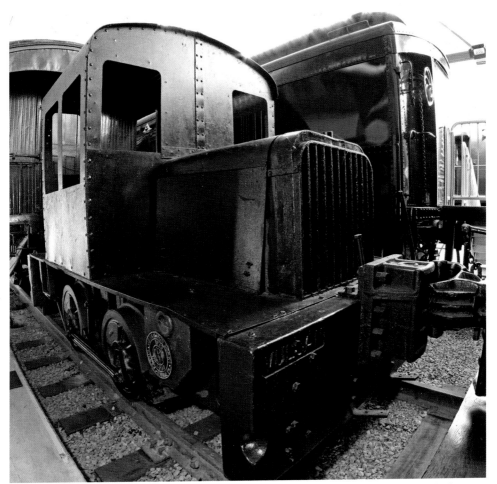

Vulcan Locomotive Works switching locomotive No. 1. Built by the Vulcan Locomotive Works in 1930. This 8-ton, standard-gauge, gas mechanical engine was used exclusively by the Vulcan Locomotive Works at its Wilkes-Barre, Pennsylvania, plant to move finished and unfinished locomotives, as well as train cars loaded with parts and supplies, around the facility.

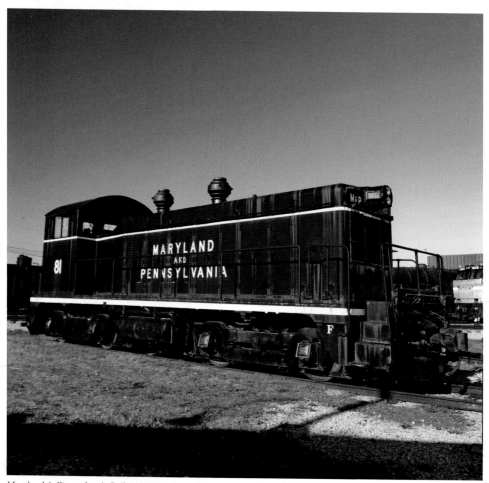

Maryland & Pennsylvania Railroad NW2 diesel-electric locomotive No. 81. Built by General Motors Electro-Motive Division in 1946. Used for switching in yards, handling road freight trains, and making the occasional passenger run. Pulled the last passenger train on the Maryland & Pennsylvania Railroad in 1954.

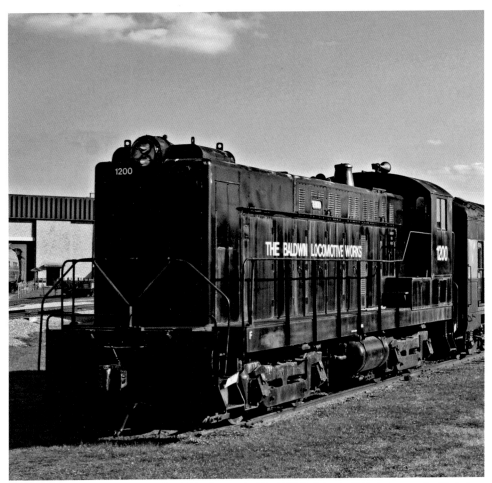

Baldwin Locomotive Works S12 diesel switching locomotive No. 1200. Built by the Baldwin Locomotive Works in 1951. No. 1200 was one of twelve locomotives of its class originally assigned to the US Navy's transportation and ordnance depots.

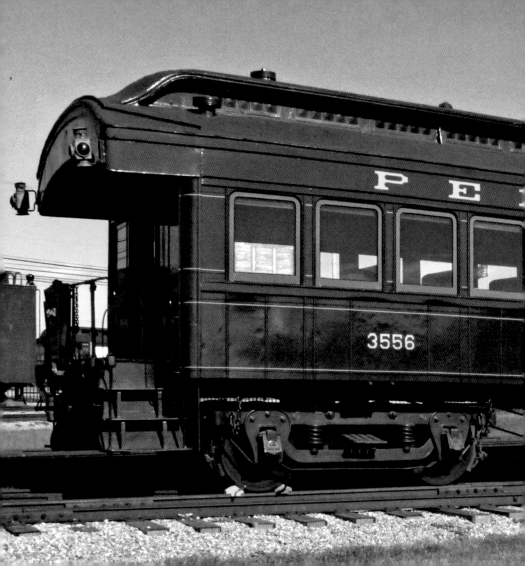

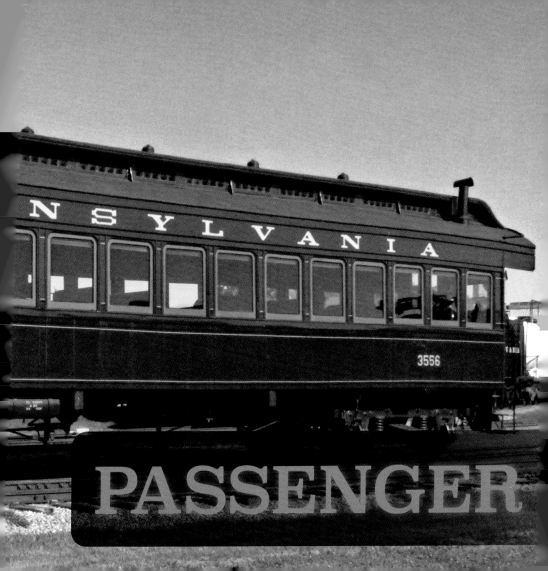

Lehigh Valley Railroad rail diesel passenger car No. 40. Built by the Budd Company in 1951. This self-propelled, stainless-steel coach was based on an 85-foot intercity passenger car and could seat eighty-nine with walkover seats. No. 40 could be used singly or with several units coupled together.

Reading Company "Crusader" stainless-steel observation car No. 1. Built by the Budd Company in 1937 and operated until 1960. One of two observation cars on the Reading Company's Crusader, the "commuter's streamliner," and the first streamlined passenger train in the East, No. 1 was equipped with rotating, reclining chairs and a separate smoking section.

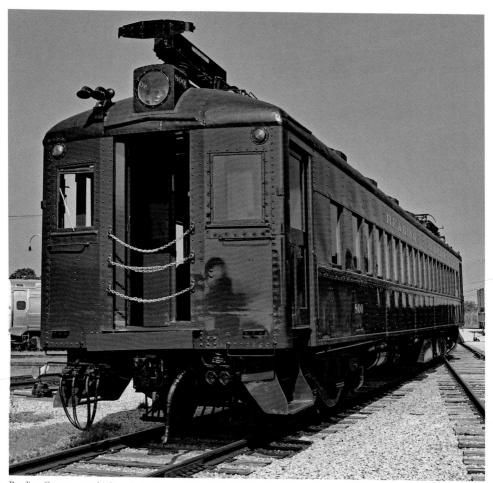

Reading Company multiple-unit electric coach No. 800. Built by Bethlehem Steel (Harlan & Hollingsworth) in 1931 and retired in 1980. No. 800 featured seating for seventy-two commuters, one bathroom, and enclosed vestibules from which the operator could control the car.

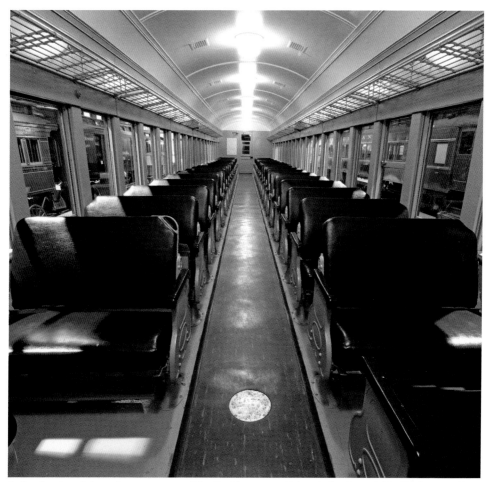

An interior view of the seating arrangement of Reading Company multiple-unit electric coach No. 800. It operated on electric train service to suburban Philadelphia communities.

Cumberland Valley Railroad wooden combination baggage/passenger coach, or "combine," No. B. Built in the Chambersburg Shops in 1855, No. B was used in passenger service until 1888, was retired in 1909, and was later restored for display at fairs and exhibitions by the Pennsylvania Railroad. ☆ ⋏

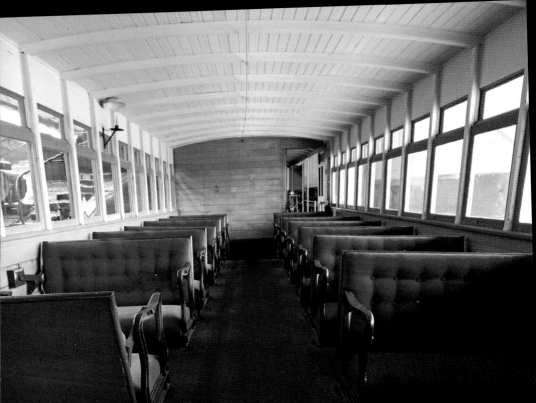

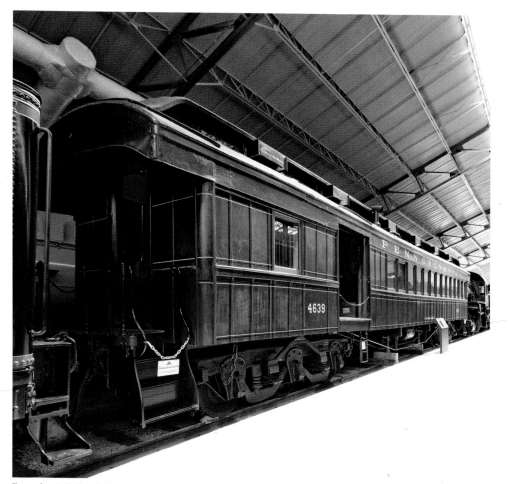

Pennsylvania Railroad Class "Og" wooden passenger/baggage car No. 4639. Built in the Altoona Shops in 1895. No. 4639 had a seating capacity of forty-two passengers, while its baggage section had pigeonholes for small express packages and occasionally US mail. ☆⋏

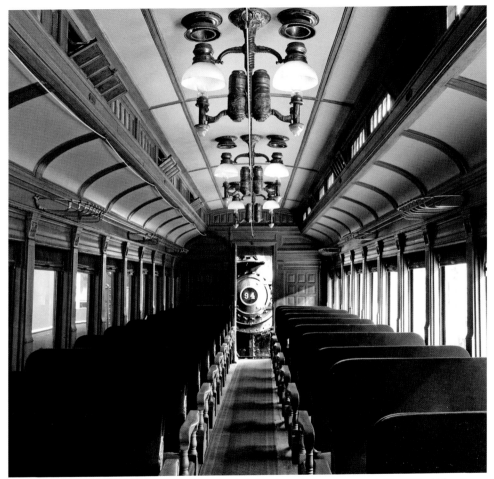

An interior view of the passenger section of Pennsylvania Railroad wooden passenger coach No. 4639, which was pulled from work train service and restored for display at the 1940 season of the New York World's Fair.

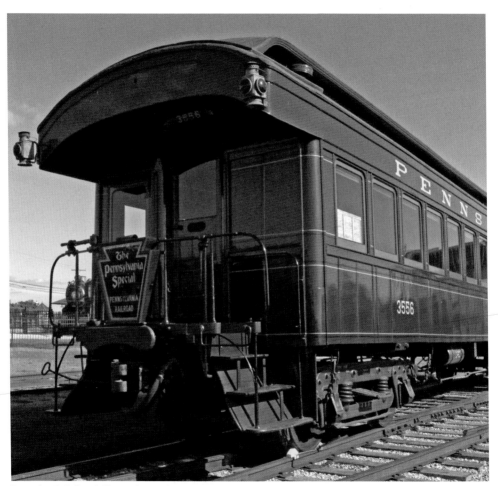

Pennsylvania Railroad Class "Pf" wooden passenger coach No. 3556. Built in the Altoona Shops in 1886. Equipped with a watercooler, toilet facilities, and a coal-burning stove at each end, it featured red plush upholstered seats, curved molding, and stained-glass clerestory windows. ☆ ⋏

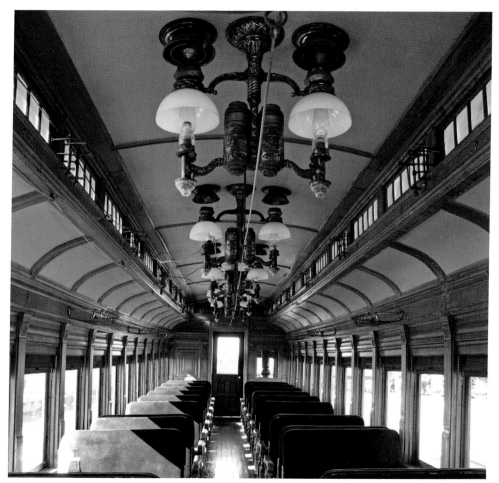

An interior view of the passenger section of Pennsylvania Railroad wooden passenger coach No. 3556, which was pulled from work train service and restored for display at the 1940 season of the New York World's Fair.

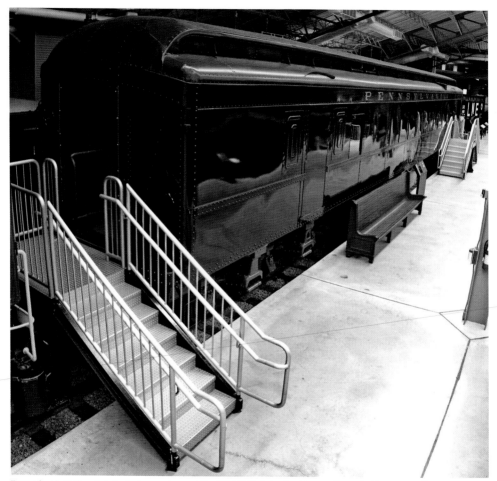

Pennsylvania Railroad air brake instruction car No. 492445. Built in the Altoona Shops in 1910, originally as a railway post office car, and retired in 1966. Rebuilt in 1928 as a mobile training facility, No. 492445 was once outfitted to simulate the air-brake characteristics of a fifty-car freight train, helping to instruct railroad employees on the use and maintenance of this equipment.

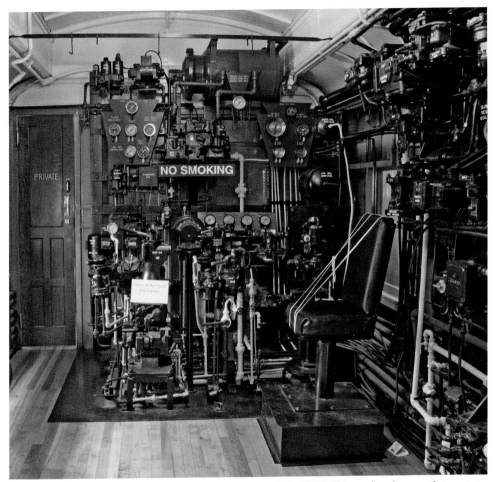

An interior view of Pennsylvania Railroad air brake instruction car No. 492445. This traveling classroom features two sections: an instructor's office and a classroom.

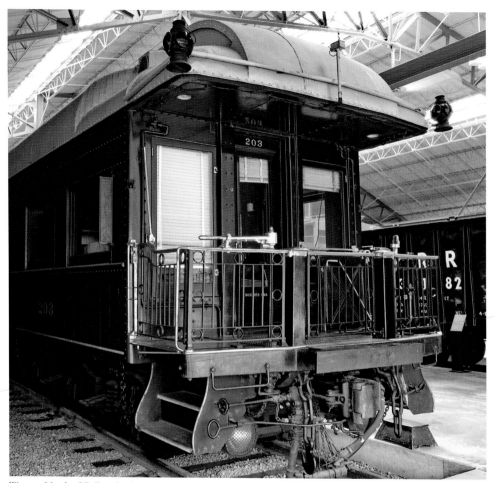

Western Maryland Railway business car No. 203. Built by Pullman in 1914 and retired in 1960. No. 203 was designed as a mobile office for high-ranking railroad executives and important clients.

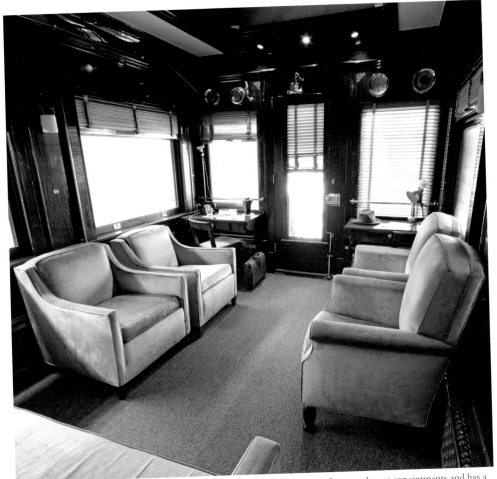

An interior view of Western Maryland Railway business car No. 203. The car features elegant appointments and has a lounge, a dining room, a kitchen, a pantry, crew quarters, bathrooms, and two master bedrooms.

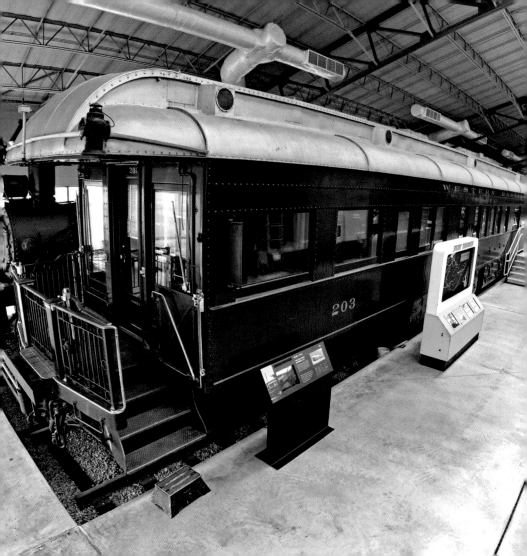

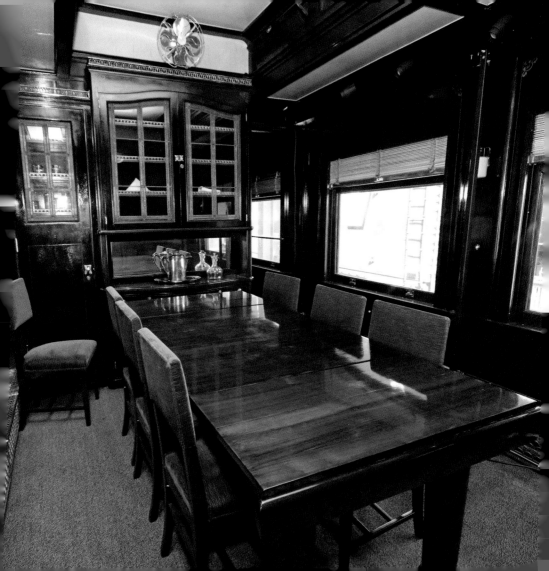

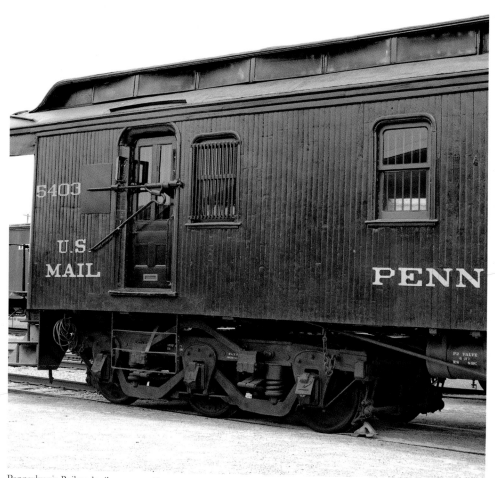

Pennsylvania Railroad railway post office car No. 5403. Built in the Altoona Shops in 1893 to carry travelers' baggage and US mail. No. 5403 originally ran on fast passenger trains between New York, Philadelphia, Pittsburgh, and Chicago. No. 5403 was pulled from work train service and restored for display at the 1940 season of the New York World's Fair. ☆ ⋏

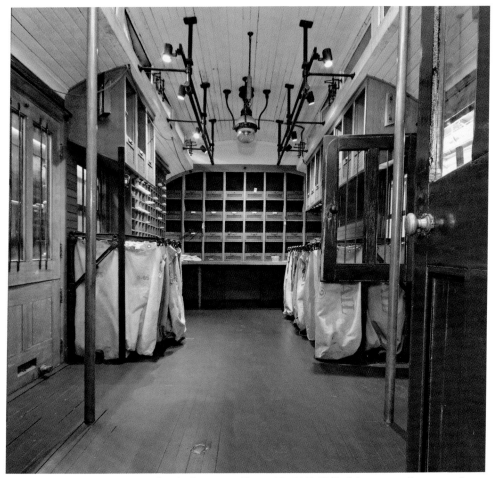

An interior view of Pennsylvania Railroad railway post office car No. 5403. Half of the car was a baggage section, while the other half had letter-sorting racks, mail pouch holders, and other equipment for processing mail in transit. A large Y-shaped hook mounted outside the mail door was for picking up mail pouches "on the fly" without slowing the train.

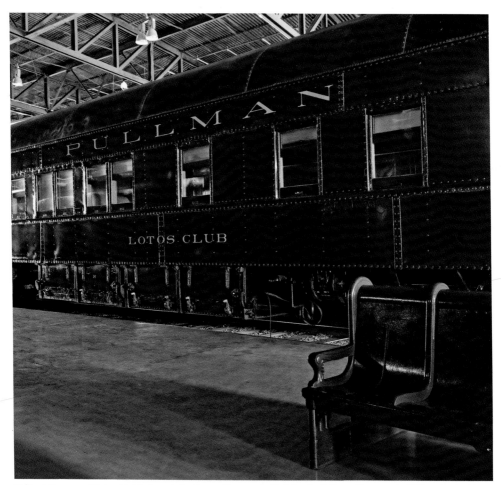

Pullman Company "Lotos Club" all-steel sleeping and lounge car. Built by the Pullman Company in 1913 and retired in 1967. Named after a fashionable New York City gentleman's literary club and often used for private parties.

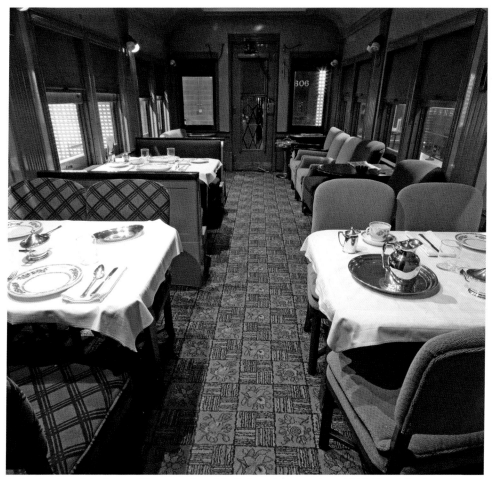

An interior view of the dining and lounge section of the Pullman Company "Lotos Club" all-steel sleeping and lounge car, which was known for comfort and the fine service by Pullman porters during the heyday of railroad travel.

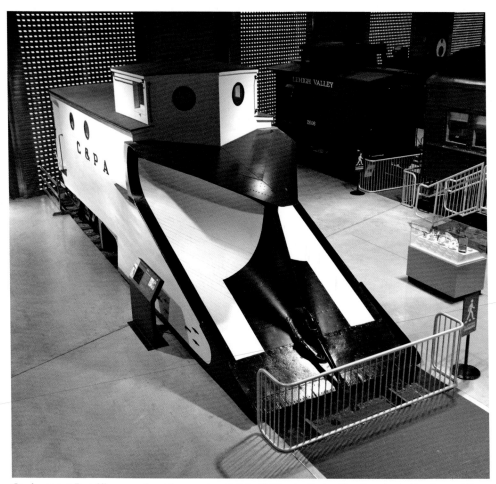

Coudersport & Port Allegany wedge-style snowplow. Built in 1897 by the Ensign Manufacturing in Huntington, West Virginia, to Russell Snowplow Company specifications. This snowplow moved heavy drifts off the rails with the assistance of one or two steam locomotives. If the drifts proved immovable and the overburdened plow became stranded, crews had to dig it out by hand.

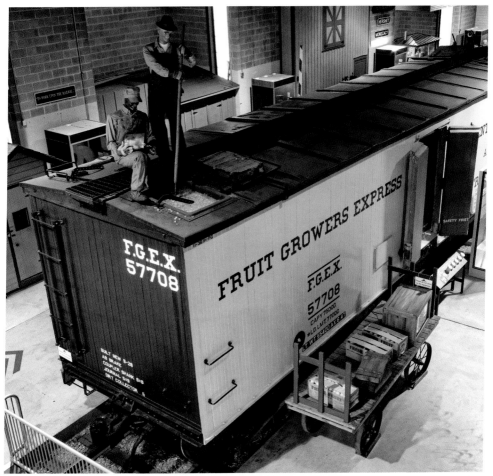

Fruit Growers Express refrigerator car No. 57708. Built by the Fruit Growers Express Company in 1928 and retired circa 1975. Workers loaded blocks of ice through rooftop hatches into large basket-type bunkers on either end of the car. Axle-driven fans then circulated air over the ice and throughout the interior, which cooled the perishable goods transported inside the heavily insulated freight car.

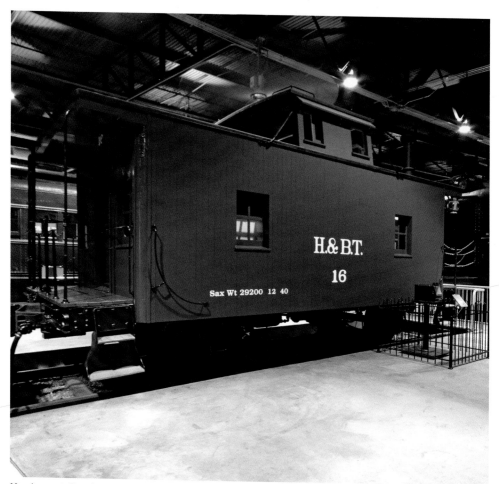

Huntington & Broad Top Mountain Railroad cabin car No. 16. Built in the Pennsylvania Railroad's Altoona Shops in 1913, this ND-class cabin car was later sold around 1940 to the Huntington & Broad Top Mountain Railroad, where it operated in freight service until 1954.

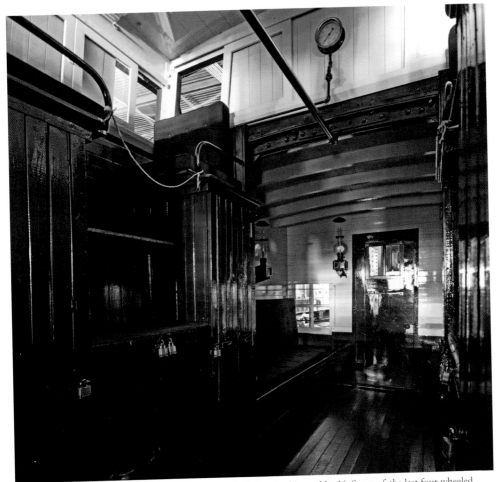

An interior view of Huntington & Broad Top Mountain Railroad cabin car No. 16. Some of the last four-wheeled "bobber" cabooses in operation, the members of the ND class, despite their wooden bodies, were among the first of their kind to have durable steel underframes.

Pennsylvania Railroad H30 covered hopper car No. 255750. Built in the Altoona Shops in 1951 and retired in 1988. Used primarily in the shipping of commodities such as grains, powdered chemicals, and granulized minerals. Its distinctive design was based on a truss structure commonly used in bridges.

Delaware & Hudson Railroad boxcar No. 19607. Built by the American Car & Foundry Company in 1907. Made of a combination of wood and steel materials, it was also used as a tool car into the 1970s.

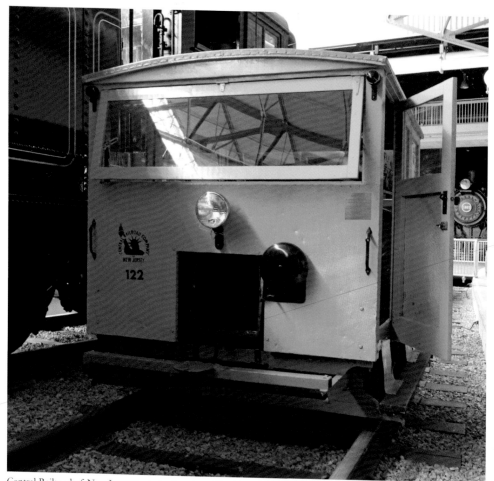

Central Railroad of New Jersey motorized track car No. 122. Built by the Fairmount Company in 1944. Known as a "speeder," this maintenance-of-way vehicle was used by the Central Railroad of New Jersey to inspect track and to shuttle work crews quickly to and from sites.

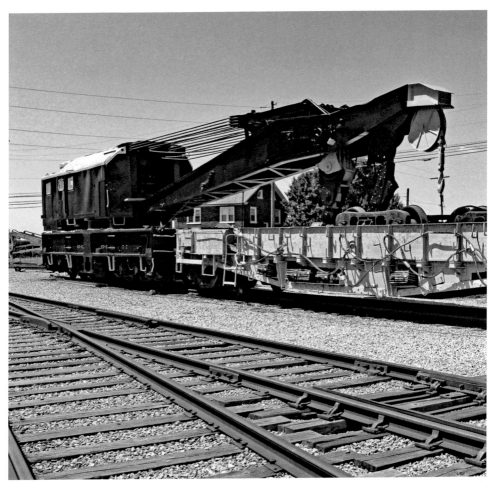

Conrail wreck crane No. 45210. Built by the Industrial Brownhoist Company in 1955 for the Erie Railroad. Paired with No. 45210 is an idler car that was converted from former PRR Class F30 flatcar No. 470189, built in 1929. Wreck cranes were used primarily to lift locomotives and rolling stock involved in derailments and other accidents, in order to get the tracks cleared up as quickly as possible.

Reading Company turntable, facing west. Built in 1928 by the American Bridge Company. This 100-foot, electrically operated turntable was originally used at the Reading Company's roundhouse in West Cressona, Pennsylvania, but was removed and reinstalled in 1946 at a different roundhouse in Bridgeport, Pennsylvania, where it remained until its retirement.

Another view, facing east, of the 1928 Reading Company turntable, which is still operating at the Railroad Museum of Pennsylvania today. A turntable is a device for turning locomotives and rolling stock in tight spaces to face a different direction, either for storage, for maintenance, or for operation.

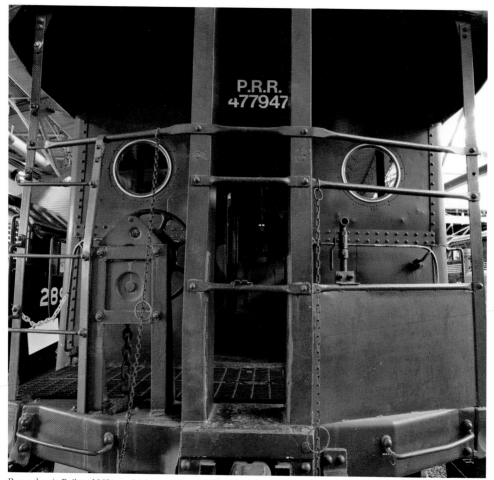

Pennsylvania Railroad N5c steel cabin car No. 477947. Built in the Altoona Shops in 1942 and retired in 1985. Its four porthole windows on each side feature glass manufactured for battleships.

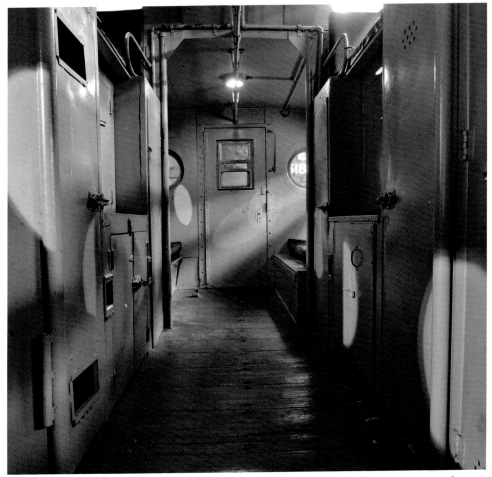

An interior view of Pennsylvania Railroad N5c steel cabin car No. 477947, which served as a crew quarters and conductor's office on freight trains.

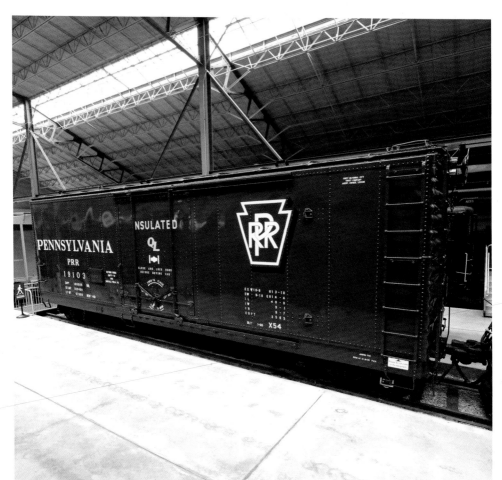

Pennsylvania Railroad X54 insulated boxcar No. 19103. Built in the Hollidaysburg Shops in 1960 and retired in 1995. No. 19103 was designed to carry perishable foodstuffs such as canned goods, and it features heavy insulation, tight-sealing doors, and a cushioned underframe.

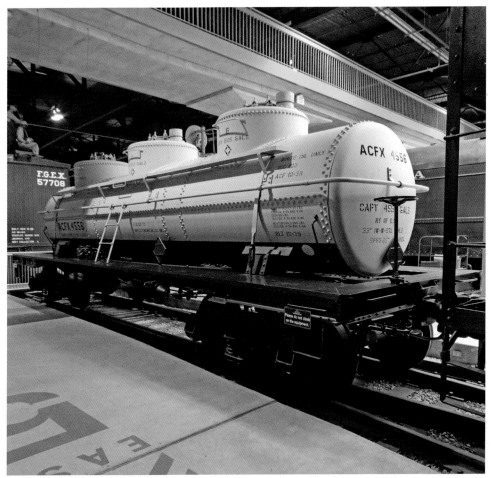

American Car & Foundry Company three-dome tank car No. 4556. Built by the American Car & Foundry Company in 1939 and retired in 1976. No. 4556 is divided into three separate sections, each of which is able to hold materials. No. 4556 carried white oil, a derivative of crude oil that manufacturers use to make numerous household goods, including plastics, cosmetics, and pharmaceuticals, among many other products.

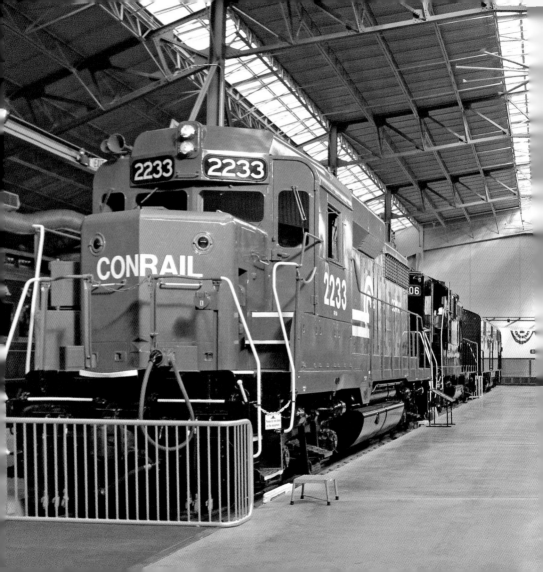

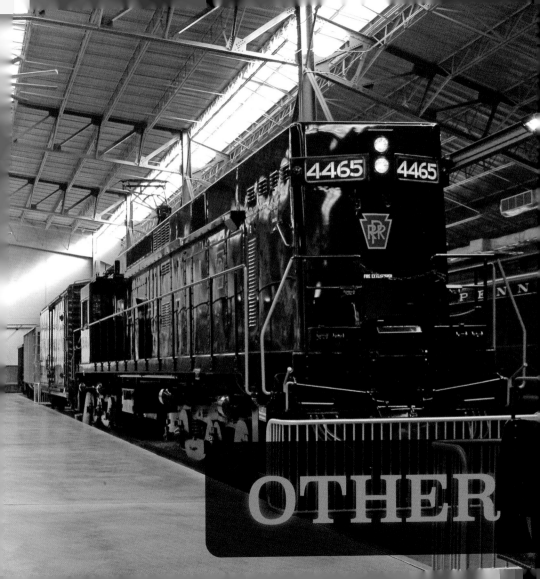

OTHER

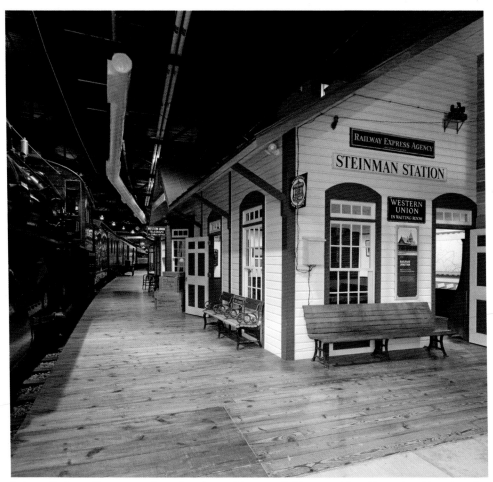

Steinman Station replica passenger depot, featuring a waiting room, freight room, ticket office, and working telegraph, represents small-town Pennsylvania stations of the early 1900s.

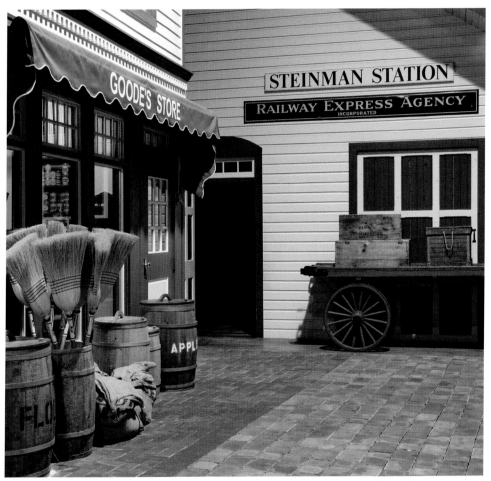

The station, an anchor exhibit in the Railroad Museum of Pennsylvania's Street Scene, was named for the Steinman family of Lancaster, Pennsylvania.

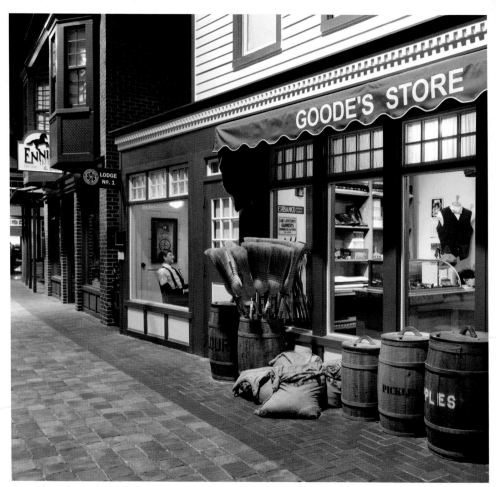

A prominent feature in the 1915 Street Scene, Goode's Store displays the type of merchandise that would have been found in the general stores of many small towns in Pennsylvania. Goode's Store was named for David R. Goode, former chairman, president, and CEO of the Norfolk Southern Corporation.

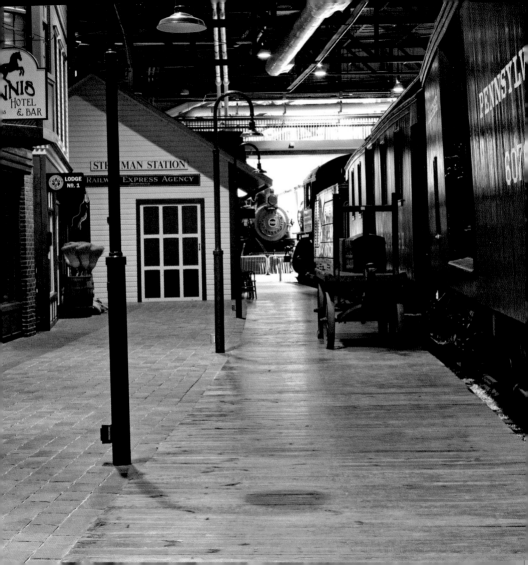

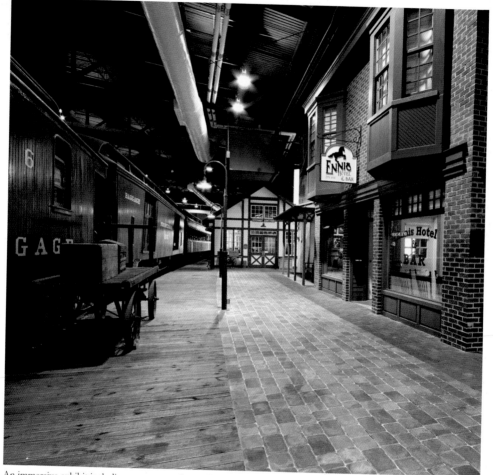

An immersive exhibit including a passenger depot, freight station, general store, hotel, union office, photography studio, and railroader's home, the Street Scene is typical of many Pennsylvania small towns during the golden age of railroading in the early 1900s. At the end of the street is Stewart Junction, a replica freight station, housing engaging hands-on activities and displays.

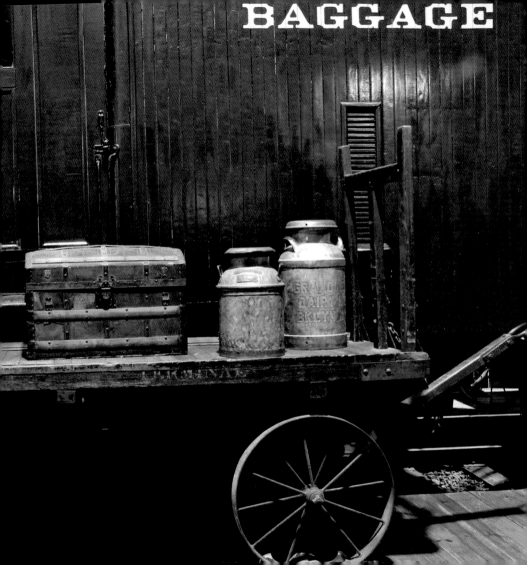

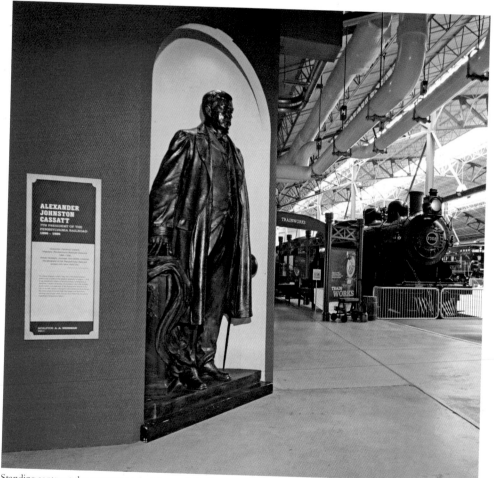

Standing sentry at the entrance to the Museum's Rolling Stock Hall is this imposing statue of Alexander Johnston Cassatt, the seventh president of the Pennsylvania Railroad. Nearly 10 feet high, the bronze statue was created by artist A. A. Weinman, cast by the Jno. Williams Inc. foundry, and unveiled at Pennsylvania Station in New York City on August 1, 1910.

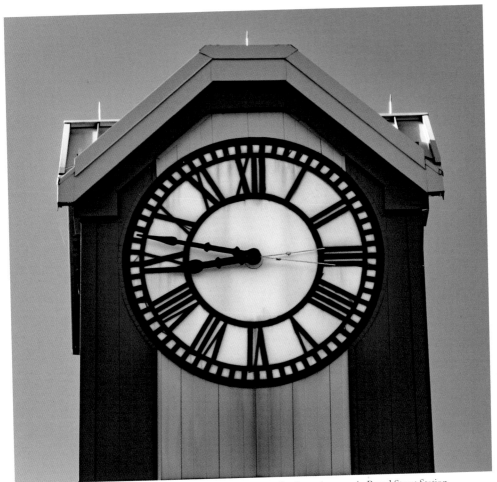

Manufactured by the Seth Thomas Company in 1881, specifically for the main tower in Broad Street Station, Philadelphia's premier railroad passenger depot. Approximately 8 feet in diameter, this clock marked the hours there until 1952. Today, it ticks on in the Railroad Museum of Pennsylvania's clock tower.

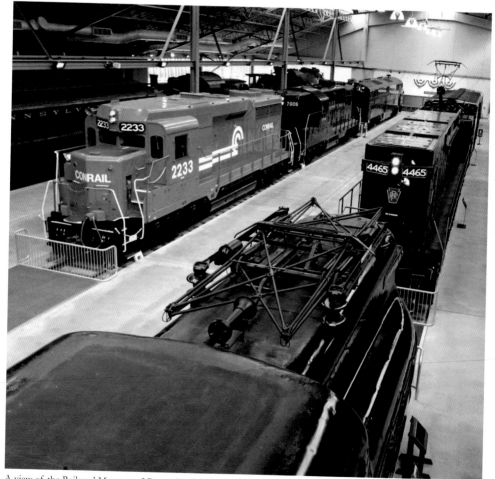

A view of the Railroad Museum of Pennsylvania's Rolling Stock Hall, looking east from the Observation Bridge.

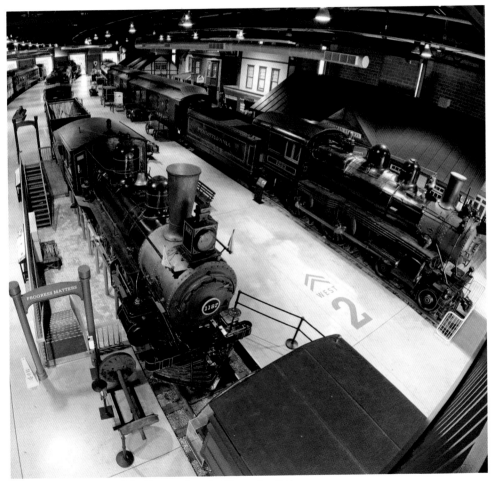

A view of Rolling Stock Hall, looking west from the Observation Bridge.

The Railroad Museum of Pennsylvania is more than just a history museum with static displays and exhibits. Visitors of all ages learn about Pennsylvania's railroad heritage with hands-on activities, primary sources, vintage vehicles, and authentic objects from the Museum's vast collections. The Museum's education programs satisfy specific academic standards in history, math, science, language arts, geography, economics, and the arts.

Begun as a grassroots volunteer effort to save historic locomotives from deterioration, the Railroad Museum of Pennsylvania's restoration program brings together workers and volunteers possessing a wide range of skills. Now based in a specially constructed shop facility, the program emphasizes stabilizing, conserving, and preserving historic railroad equipment to the highest standards, balancing cosmetic authenticity with practicality.

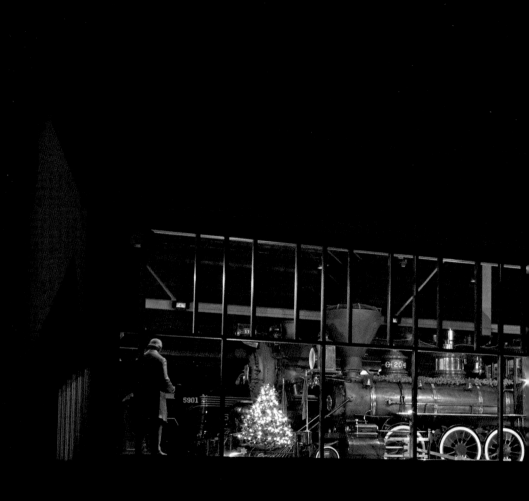

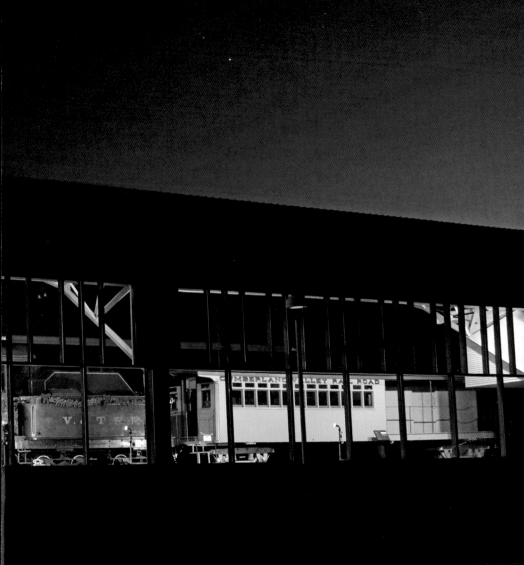

Copyright © 2022 by The Friends of the Railroad Museum of Pennsylvania

Library of Congress Control Number: 2022932592

Cover design by Chris Bower

Inside front cover image: Opened in 1893 for the Philadelphia & Reading Railway, Reading Terminal in Philadelphia, Pennsylvania, served passengers until 1984. In the 1990s, the building was transformed into the new Pennsylvania Convention Center. Although trains no longer pass through it, Reading Terminal's train shed remains one of the oldest and widest arched-roof structures in the world. *PHMC, Railroad Museum of Pennsylvania (RR2005.39, neg #630)*

Inside back cover image: Completed in 1908, this grand Beaux-Arts-style Lackawanna Station in Scranton, Pennsylvania, was originally built for the Delaware, Lackawanna & Western Railroad. The last train served the station in 1970. After extensive renovations, it reopened in 1983 as a grand hotel. *PHMC, Railroad Museum of Pennsylvania (General Photo Collection)*

Type set in Superclarendon/Garamond

ISBN: 978-0-7643-6513-3
Printed in India
5 4 3 2

MIX
Paper from responsible sources
FSC® C016779
www.fsc.org

Published by Schiffer Publishing, Ltd.
4880 Lower Valley Road
Atglen, PA 19310
Phone: (610) 593-1777; Fax: (610) 593-2002
E-mail: Info@schifferbooks.com
Web: www.schifferbooks.com

Schiffer Publishing's titles are available at special discounts for bulk purchases for sales promotions or premiums. Special editions, including personalized covers, corporate imprints, and excerpts, can be created in large quantities for special needs. For more information, contact the publisher.